LEARN TO DRAW

(ALMOST) ANYTHING

in 6

EASY
STEPS

LEARN TO DRAW

(ALMOST) ANYTHING in **6** EASY STEPS

RICH DAVIS

Race Point
PUBLISHING

Inspiring | Educating | Creating | Entertaining

Brimming with creative inspiration, how-to projects, and useful information to enrich your everyday life, Quarto Knows is a favorite destination for those pursuing their interests and passions. Visit our site and dig deeper with our books into your area of interest: Quarto Creates, Quarto Cooks, Quarto Homes, Quarto Lives, Quarto Drives, Quarto Explores, Quarto Gifts, or Quarto Kids.

This edition published in 2020 by Race Point Publishing, an imprint of The Quarto Group, 142 West 36th Street, 4th Floor, New York, NY 10018, USA

First published in 2016 as the *The 1-Minute Artist* by Race Point Publishing, an imprint of The Quarto Group, 142 West 36th Street, 4th floor, New York, NY 10018, USA
T (212) 779-4972 F (212) 779-6058 www.QuartoKnows.com

Race Point Publishing titles are also available at discount for retail, wholesale, promotional, and bulk purchase. For details, contact the Special Sales Manager by email at specialsales@quarto.com or by mail at The Quarto Group, Attn: Special Sales Manager, 100 Cummings Center Suite 265D, Beverly, MA 01915 USA.

10 9 8 7 6 5 4 3 2 1

ISBN: 978-1-63106-716-7

Publisher: Rage Kindelsperger
Creative Director: Laura Drew
Managing Editor: Cara Donaldson
Senior Editor: Erin Canning
Art Director: Cindy Samargia Laun
Interior Design: Melissa Gerber and Diana Boger

Printed in China 1010032020

CONTENTS

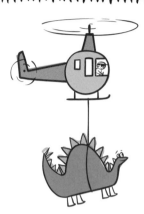

INTRODUCTION

This book teaches both adults and children how to draw everyday things in a whimsical style—quickly and easily—in 6 or 12 steps. The beauty of the drawings in this book is that they are simple, easy to learn, take very little time to accomplish a lot, and fun. The confidence that comes from artistic experimentation is powerful. Pair that with the confidence that comes from repetition and you have a winning combination. Artistic experimentation also encourages the development of ideas—those ideas will not be limited just to drawing, but to other areas of one's imagination and learning experience. It's never too late to learn how to draw, and this book is the perfect introduction!

The eight sections of this book have distinct themes, such as animals, architecture, transportation, and people. You may notice that there is often crossover among the sections (e.g., a bird wearing a hat). This encourages the budding artist to imagine the possibilities and combine creations across the sections. There are also creative prompts included at the beginning of each section, called Here's Some Inspiration, along with additional sketches to experiment with on the Try These Too! pages.

Black lines are what
is done in that step.

Blue lines are
erasures.

Gray lines are from
previous steps.

How to Use This Book

The most important thing to keep in mind is that there are no strict rules to follow and deviating from the lines in this book is encouraged. For simplicity, black lines are what is done in that step, gray lines are from previous steps, and blue lines are erasures.

When using this book, always try to have scrap paper on hand for practicing. The cartoonish creations you learn to make in 6 or 12 steps invite you to combine them to create scenes and stories. Drawing on scrap paper will help you practice the sketch before adding it to a scene. If a complicated scene involving multiple elements is in progress, scrap paper helps people of any age group keep calm; there's little chance of ruining the scene . . . but there's also nothing wrong with making—and learning—from mistakes.

ANIMALS

In this chapter you'll learn how to draw your favorite animals, including dogs, cats, cows, frogs, rabbits, and more . . . all in just 6 easy steps! To get even more creative, try some of the suggestions for creating an animal scene on the opposite page and give the sketches a whirl on pages 24 and 25. And don't forget your 12-Step Challenge—see if you can draw the ice-skating penguin on page 26!

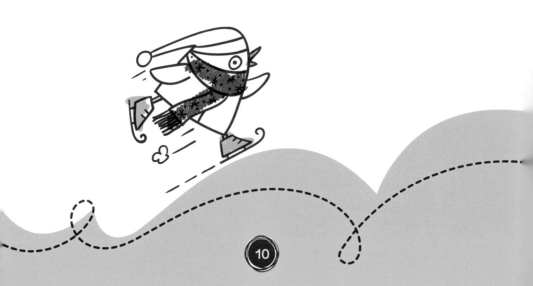

Here's Some
INSPIRATION

Make a scene using the animals in this chapter!

Once you've mastered all the animals in this chapter, try making a scene with them! This is the fun part. I put some suggestions below to jump-start your creativity. And don't hesitate to use your new sketching skills to modify any of the animals here. Experiment with them in different poses or have them do "people" things like eat pizza or play soccer. The sky is the limit!

• Draw a frog (page 16) sitting on a lily pad. Then, draw a penguin ice skating (page 26) in front of the frog. Throw a hat (page 125) on the frog to keep him warm!

• What is the turtle (page 19) running from? Use something from the transportation chapter (page 70) to show what he is running from.

• Give your animals some character and emotion by adding thought bubbles near them. What are they thinking about? Write or draw it in!

• Draw the jumping cat (page 15). Why is he so happy? Is it his birthday? Or is he glad to see someone? Draw it in!

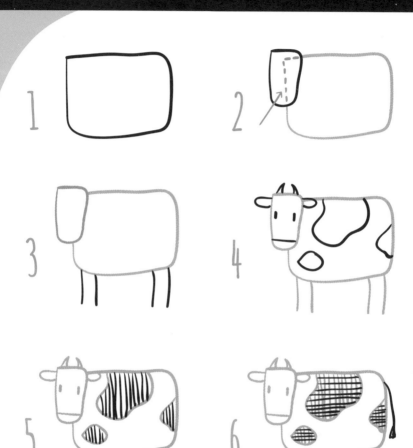

1

2

3

4

5

6

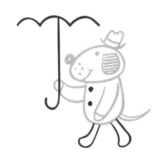

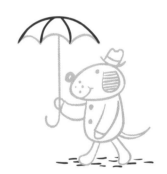

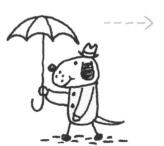

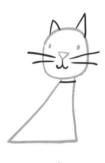

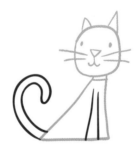

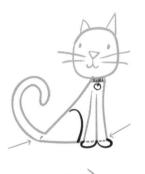

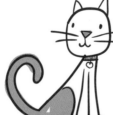

JUMPING CAT

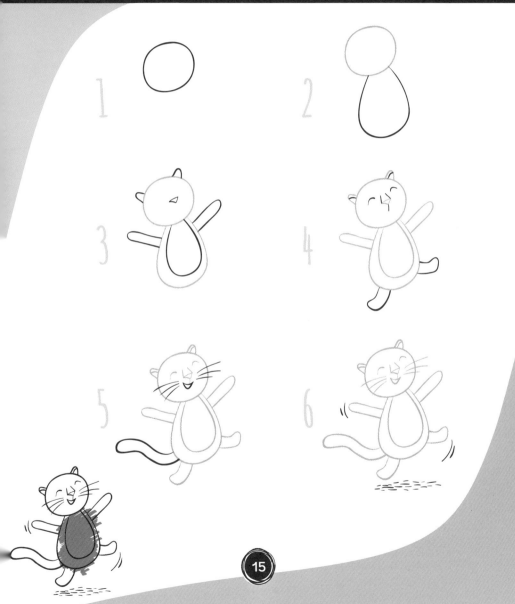

1

2

3

4

5

6

BOING!

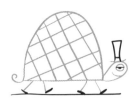

RUNNING TURTLE

1

2

3

4

5

6

1

2

3

4

5

6

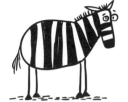

BRONTOSAURUS

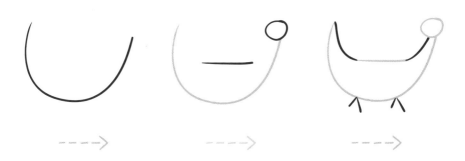

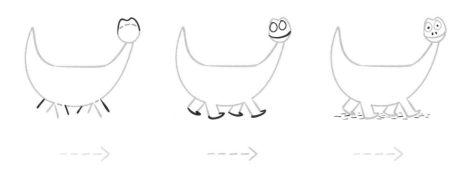

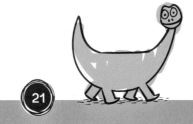

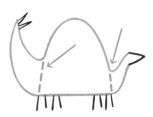

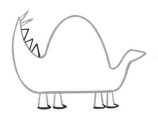

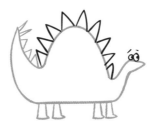

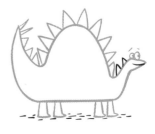

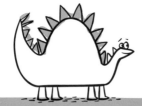

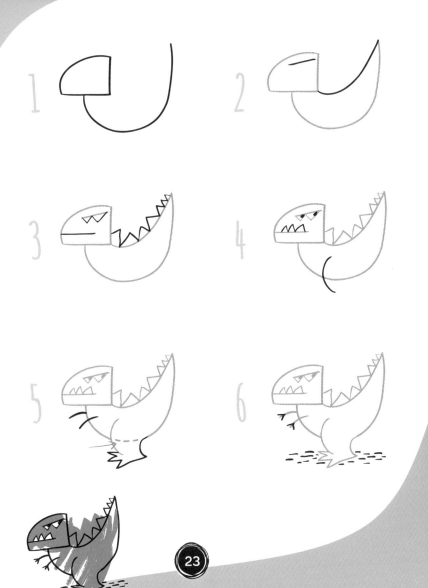

TRY *these* TOO!

Now that you're a pro at drawing animals, give these active creatures a try.

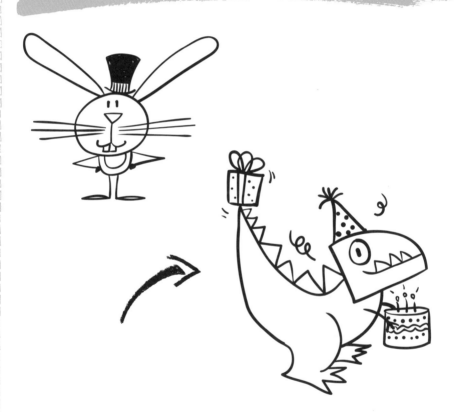

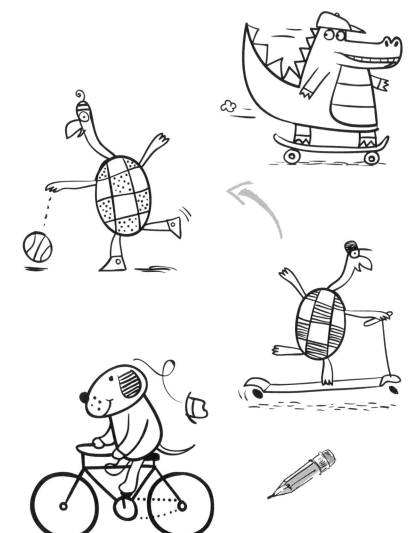

ICE-SKATING PENGUIN

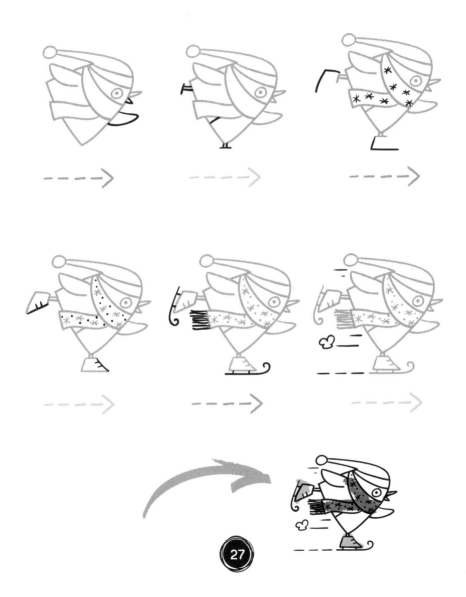

BIRDS

In this chapter you'll learn how to draw different birds, including ducks, chickens, roosters, hens, and more . . . all in just 6 easy steps! To get even more creative, try some of the suggestions for creating a bird scene on the opposite page and give the sketches a whirl on page 37. And don't forget your 12-Step Challenge—see if you can draw the mom and chick on page 38!

Birds can add life to any scene, whether they're flying above buildings or nesting in trees.

Once you've mastered all the birds in this chapter, try making a scene with them! This is the fun part. I put some suggestions below to jump-start your creativity. And don't hesitate to use your new sketching skills to modify any of the birds here. Experiment with them in different poses or have them do "people" things like wear hats (page 125) or read a book. The sky is the limit!

- Always make your first line a decent size—not too big, but not too small. This will give you more room to draw the rest of the bird and create a scene around it.

- Quickly look at a step, remember it, and then quickly draw it. Do that for every step until your bird is finished. Don't worry about what your bird looks like at first! Practice will make it get better!

- Try to avoid erasing anything until after you've finished drawing the bird. Erasing might take longer than simply starting from scratch!

- Once you've drawn a bird, try drawing it again to see if you can improve upon it.

- After you have drawn 2 or 3 different birds, draw 2 birds facing each other. Draw some speech bubbles and write a conversation between them. Are they friends? Or enemies?

1

2

3

4

5

6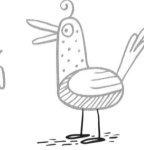

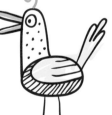

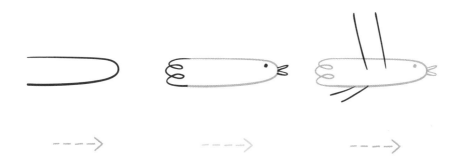

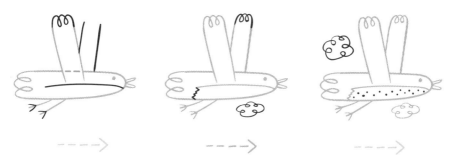

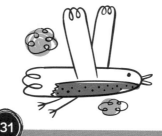

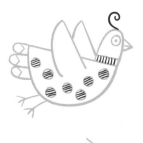

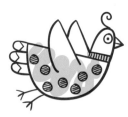

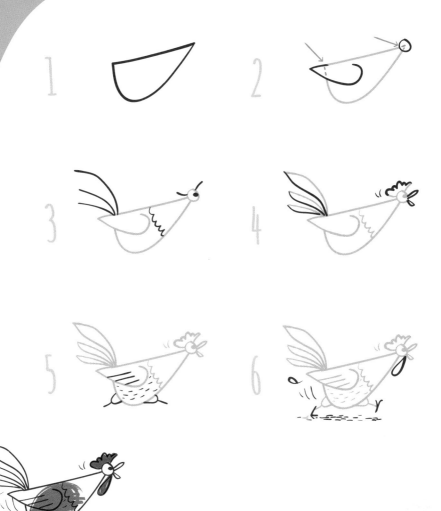

FANCY BIRD

1

2

3

4

5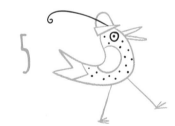

6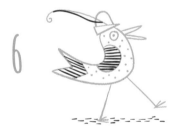

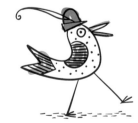

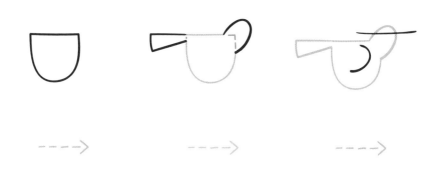

LADY BIRD

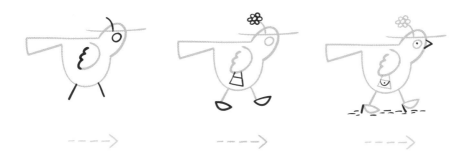

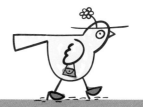

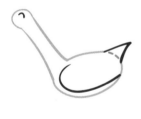

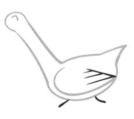

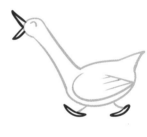

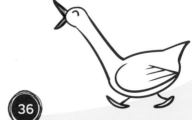

TRY *these* TOO!

Now that you're a pro at drawing birds, give these feathered friends a try.

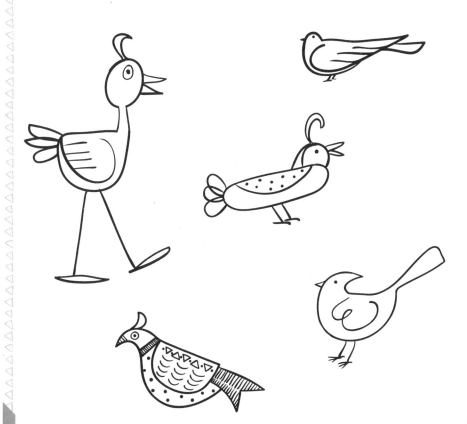

MOM AND CHICK

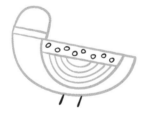

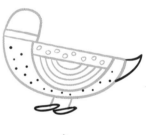

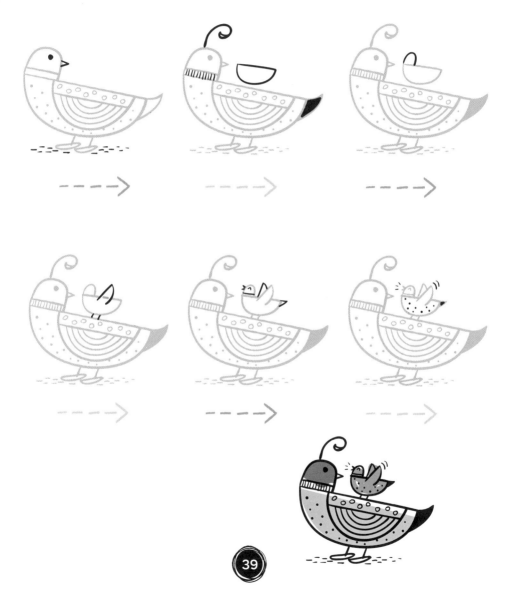

39

FISH

In this chapter you'll learn how to draw various fish, real and imagined . . . all in just 6 easy steps! To get even more creative, try some of the suggestions for creating a scene with them on the opposite page and give the sketches a whirl on page 51. And don't forget your 12-Step Challenge—see if you can draw the angelfish on page 52!

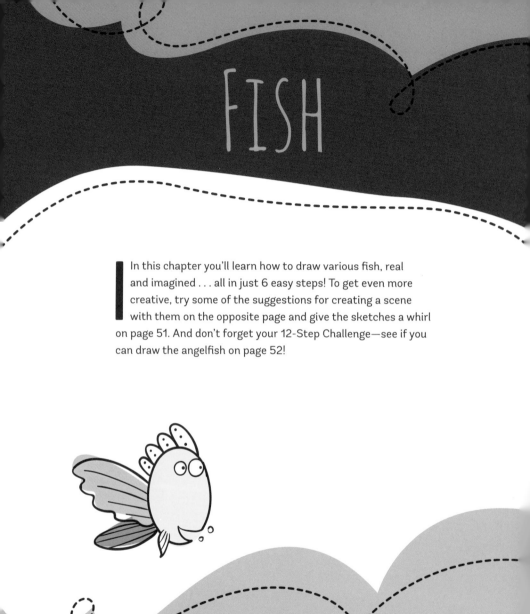

Create a school of fish from the drawings in this chapter.

Once you've mastered all the fish in this chapter, try making a scene with them! This is the fun part. I put some suggestions below to jump-start your creativity. And don't hesitate to use your new sketching skills to modify any of the creatures here or create an entirely new fish. Experiment with them in different places or even have them do "people" things. The sky is the limit!

• Draw the 12-step fish (page 52) large, to fill up a lot of the scene. Surround it with some other, smaller fish from the chapter. Add some thought bubbles to show what they are thinking!

• Draw your own make-believe fish (page 50) by choosing some different shapes to start with. Then, add eyes, a mouth, and fins. Try drawing the eyes large and the mouth small or vice versa to see how that changes the appearance. Don't forget to give your fish a name!

• Draw any 3 fish from this chapter. Add a hat (page 125) to each fish to make a comical scene!

• Draw a submarine (page 76) and then some fish around it looking into the windows.

• Draw an old Viking ship (page 78) sunk at the bottom of the ocean. Add some unexpected things around it, and then draw some fish looking at the scene with surprised faces.

1

2

3

4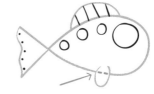

5

6

PUFFER FISH

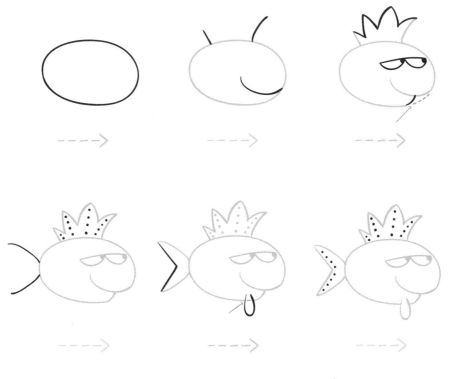

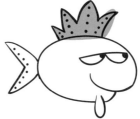

FISH PIRANHA ⇨ ⇨

BOXFISH ⇨ ⇨ ⇨ ⇨

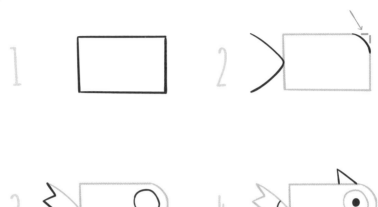

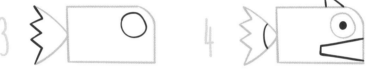

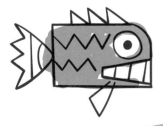

1

2

3

4

5

6

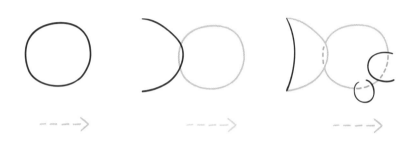

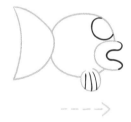

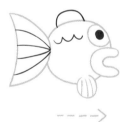

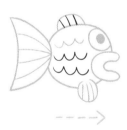

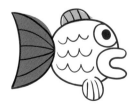

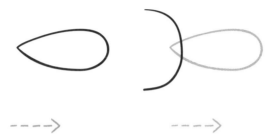

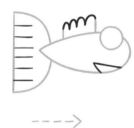

GUPPY

TRY *these* TOO!

Now that you're a pro at drawing fish, give these hat-wearing swimmers a try.

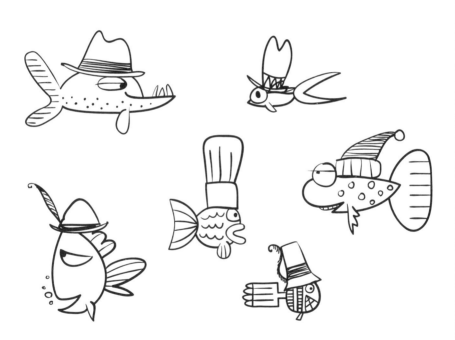

ANGELFISH

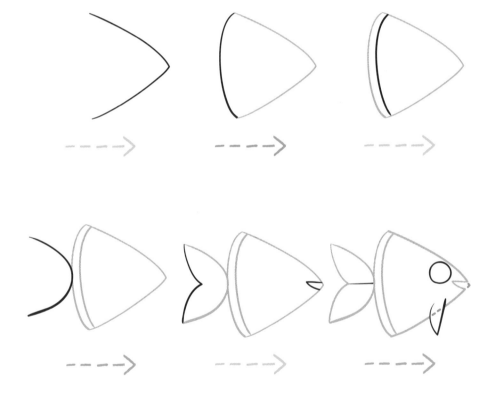

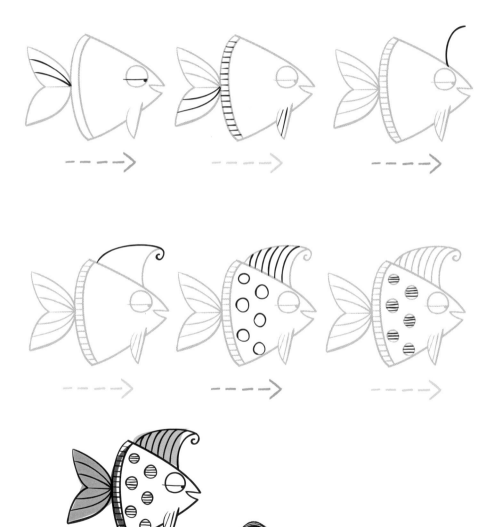

ARCHITECTURE

In this chapter you'll learn how to draw different buildings, including houses, castles, barns, grass huts, and even some famous buildings, such as Notre Dame and the White House . . . all in just 6 easy steps! To get even more creative, try some of the suggestions for creating a city scene on the opposite page and give the sketches a whirl on pages 66 and 67. And don't forget your 12-Step Challenge—see if you can draw the Brandenburg Gate on page 68!

Build a scene with the structures in this chapter!

Once you've mastered all the buildings in this chapter, try making a scene with them! This is the fun part. I put some suggestions below to jump-start your creativity. And don't hesitate to use your new sketching skills to modify any of the buildings here. Experiment with them in different environments and combinations. The sky is the limit!

- Start with the first shape drawn fairly large in the middle of the paper so you don't run out of room on the sides, top, or bottom when you draw the rest of the scene.

- Add some details to the building like bricks, stones, shutters on the windows, and a door for the entrance.

- When you have finished the building, add some trees (page 101) around your building.

- How do people get to the building? Add some transportation (page 70) options—like a car in front of the building or a helicopter above it. Draw something unexpected!

- Draw some people (page 112) coming out of your building. Invent a story about their lives!

- Try drawing 2 or 3 different kinds of buildings on the same piece of paper. Make a little neighborhood of your constructions.

1

2

3

4

5

6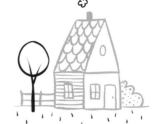

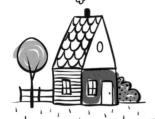

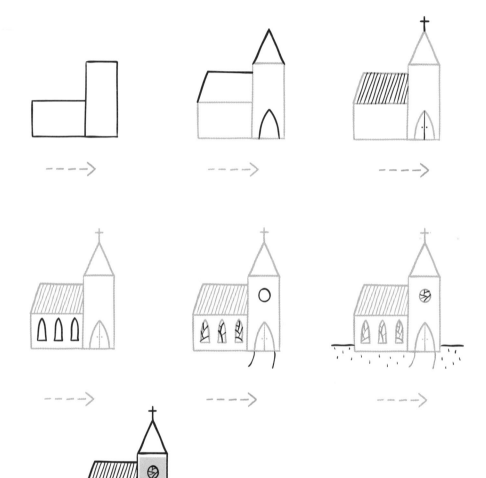

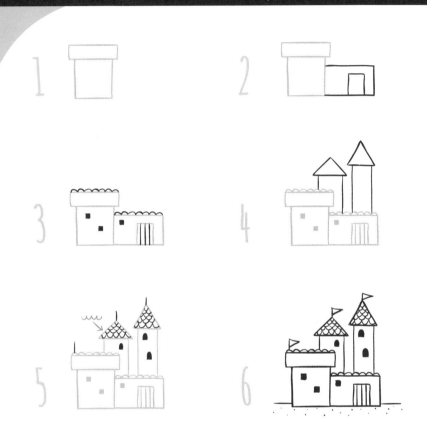

1

2

3

4

5

6

1

2

3

4

5

6

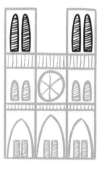

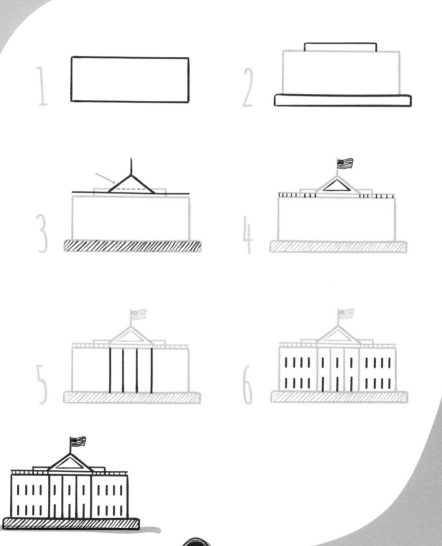

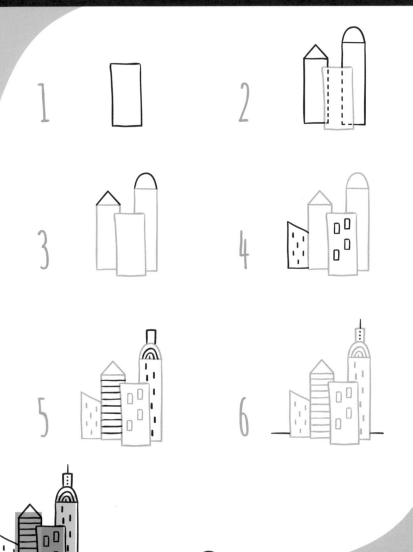

1

2

3

4

5

6

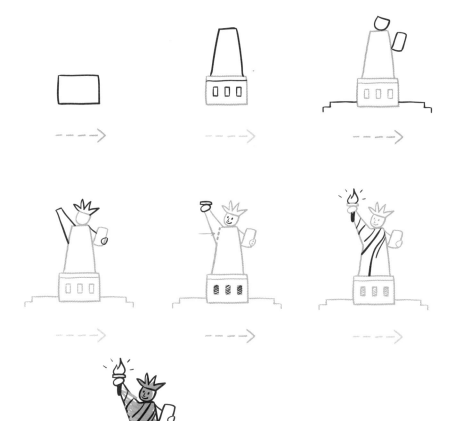

TRY *these* TOO!

Now that you're a pro at drawing, architecture, give these whimsical houses a try.

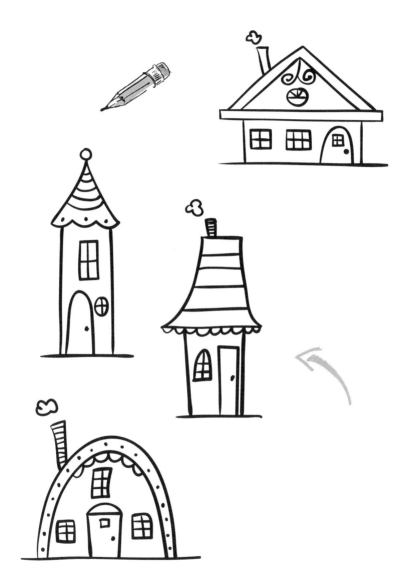

BRANDENBURG GATE

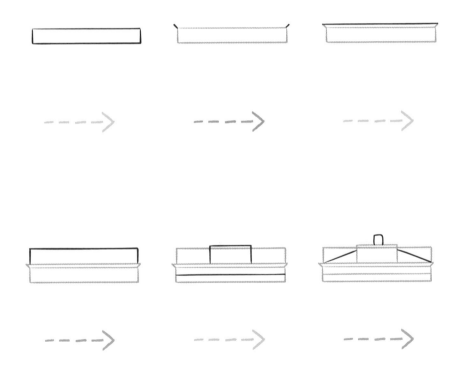

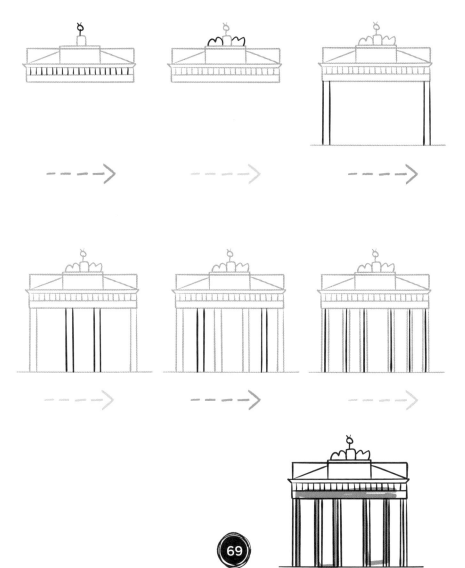

TRANSPORTATION

n this chapter you'll learn how to draw some common and uncommon modes of transportation, from cars to airplanes to boats . . . all in just 6 easy steps! To get even more creative, try some of the suggestions for creating a scene with them on the opposite page and give the skethces a whirl on pages 82 and 83. And don't forget your 12-Step Challenge—see if you can draw the locomotive on page 84!

Here's Some
INSPIRATION

Your towns and people need ways to get around! Add some modes of transportation to your scenes.

Once you've mastered all the modes of transportation in this chapter, try making a scene with them! This is the fun part. I put some suggestions below to jump-start your creativity. And don't hesitate to use your new sketching skills to modify any of the vehicles here. Experiment with different drivers, passengers, and locations. Have fun! The sky is the limit!

- Vehicles are usually moving. Don't forget to draw little lines behind them showing how fast they are going. For vehicles that are stopped (like a car at a traffic light), don't add these lines.

- Look at the shape of the car (page 74). Experiment with different shapes to create a new car! Your imagination is the only limit.

- Runaway vehicles! Most of the things in this chapter don't have anybody driving them. Add an animal (page 10) or person (page 112) in the driver's seat so that there is someone in control of the vehicle.

- Draw the helicopter (page 81) flying, with a rope hanging down carrying something unexpected. Maybe it's carrying a person (page 112) or a fish (page 40)? Or possibly a building (page 54) or an exploding volcano (page 108)! Write a story about your picture explaining how all of these elements came together.

- Try putting big wheels on a vehicle instead of small wheels. This allows cars and trucks to be higher off the ground and pass over obstacles easier.

1

2

3

4

5

6

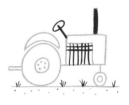

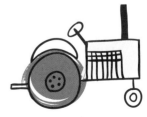

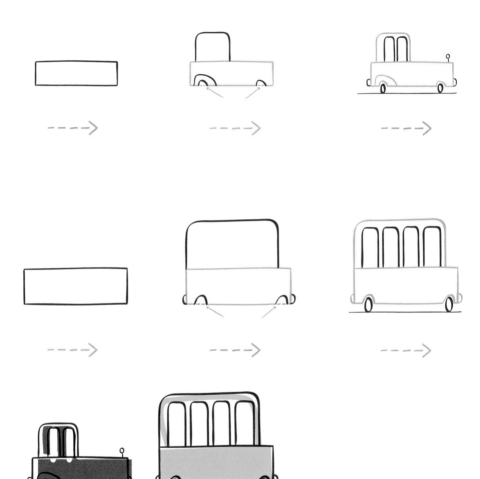

TRUCK

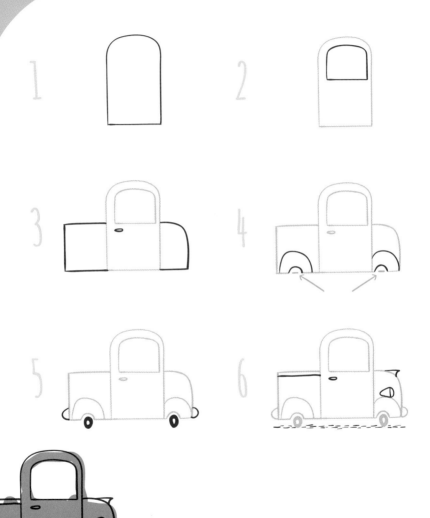

1 ─────

2

3

4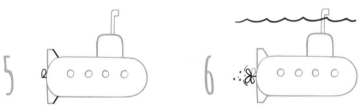

5

6

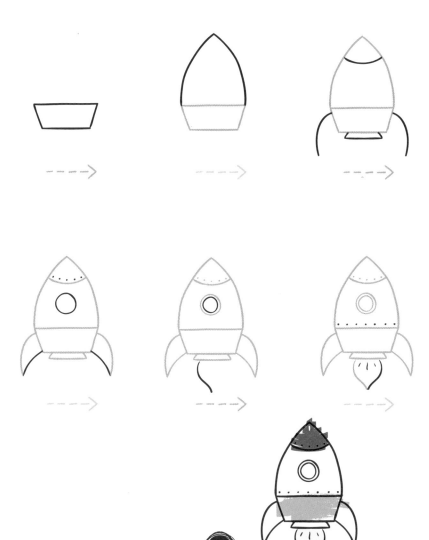

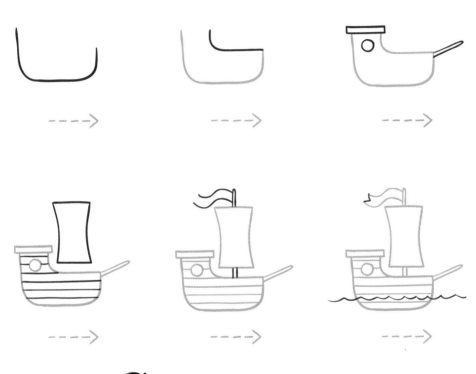

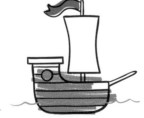

1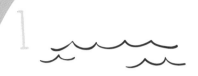

2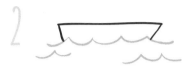

3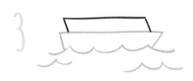

4

5

6

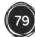

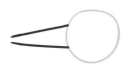

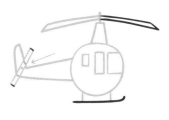

TRY these TOO!

Now that you're a pro at drawing, transportation, give these rides a try.

LOCOMOTIVE

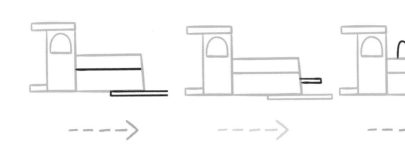

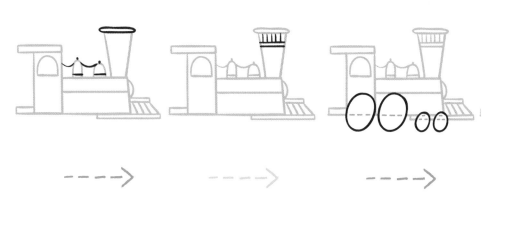

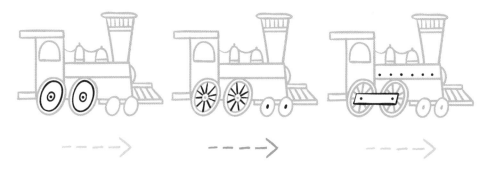

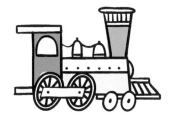

GARDEN

I n this chapter you'll learn how to draw the different things found in a garden . . . all in just 6 easy steps! To get even more creative, try some of the suggestions for creating a scene with them on the opposite page and give the sketches a whirl on page 95. And don't forget your 12-Step Challenge—see if you can draw the gardener on page 96!

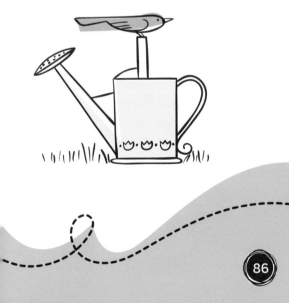

Here's Some
INSPIRATION

Create a serene garden with some of the calming elements in this chapter.

Once you've mastered all the things that go in a garden, try making a scene with them! This is the fun part. I put some suggestions below to jump-start your creativity. And don't hesitate to use your new sketching skills to modify any of the things here. Experiment with different flowers, plants, insects, and gardeners. The sky is the limit!

- Draw the flower bed (page 90) and then add some dragonflies (page 93) and butterflies (page 94) flying around them. Add some people (page 112) and animals (page 10) enjoying the beautiful day in a serene park!

- Sketch the potted flowers (page 89) and then draw the watering can (page 91) watering the pots. Who is holding the watering can?

- Draw a house (page 56) and then add some flowers to the garden around it. Who lives in the house? Do they take care of the garden and lawn? Write a story about them!

1

2

3

4

5

6

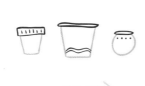

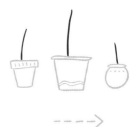

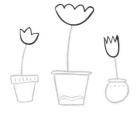

WATERING CAN

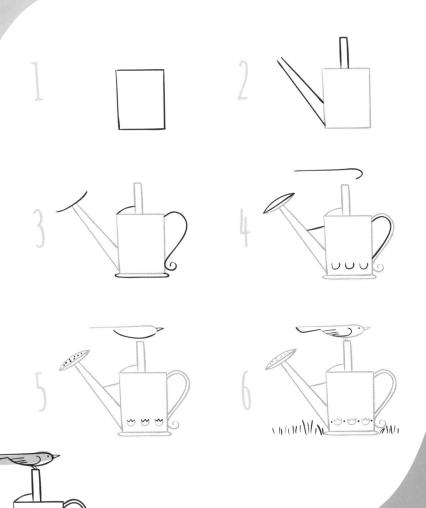

1

2

3

4

5

6

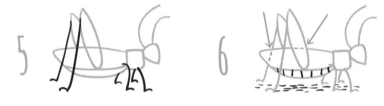

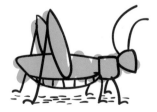

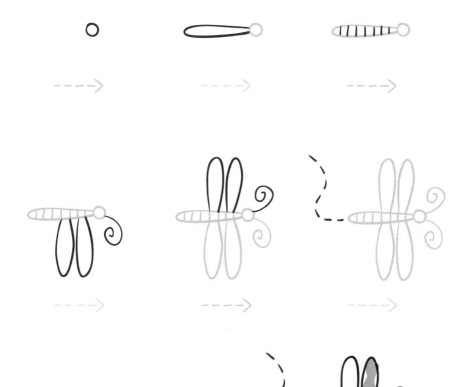

TRY *these* TOO!

Now that you're a pro at drawing things found in a garden, give these lovely flowers a try.

GARDENER

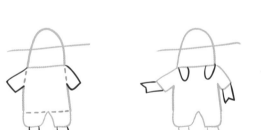

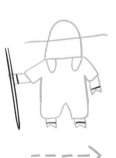

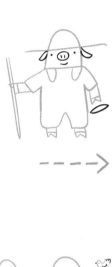

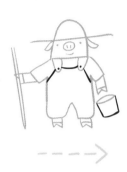

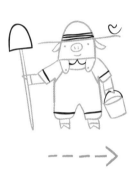

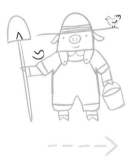

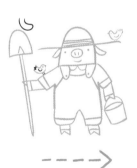

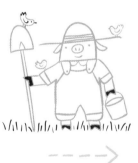

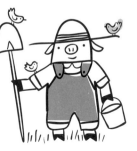

GREAT OUTDOORS

In this chapter you'll learn how to draw things found in the great outdoors . . . all in just 6 easy steps! To get even more creative, try some of the suggestions for creating a scene with them on the opposite page and give the sketches a whirl on page 109. And don't forget your 12-Step Challenge—see if you can draw the baobab tree on page 110!

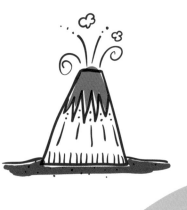

Here's Some
INSPIRATION

Make a nature scene using the elements in this chapter.

Once you've mastered all the things found in the great outdoors, try making a scene with them! This is the fun part. I put some suggestions below to jump-start your creativity. And don't hesitate to use your new sketching skills to modify any of the things here. Experiment with different seasons and perspectives! Fill your scenes with quirky combinations from this—and other—chapters. The sky is the limit!

- See if you can combine several different things from this chapter into one image. Perhaps draw a mountainside (page 107) with trees on it? Or a forest (page 104) of many different kinds of trees.

- Draw a snowman (page 106) standing someplace unexpected, such as next to the Statue of Liberty (page 65). Draw a ship (page 78) going past the statue and snowman. Write a story about how the snowman ended up next to the Statue of Liberty!

- Draw a mountain range (page 107), and then add an airplane (page 80) flying far above it.

- Experiment with making some of your own trees. Remember to start with a big, simple shape first and then add to it.

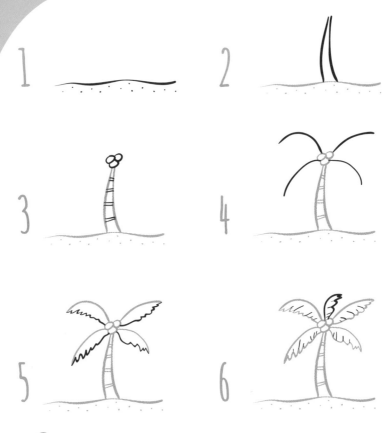

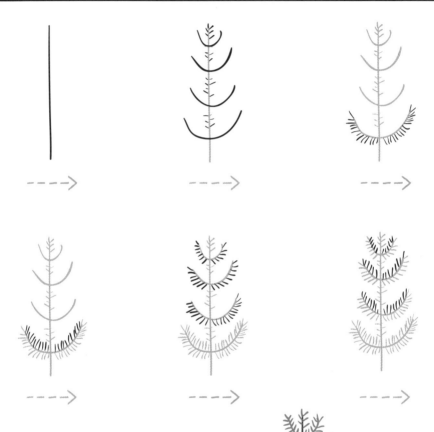

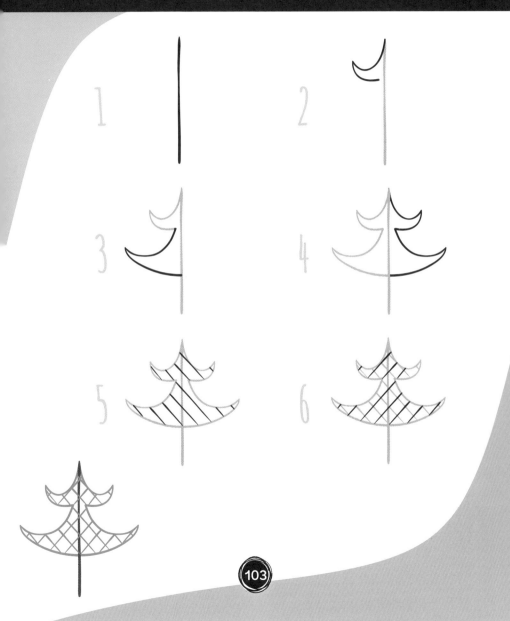

1

2

3

4

5

6

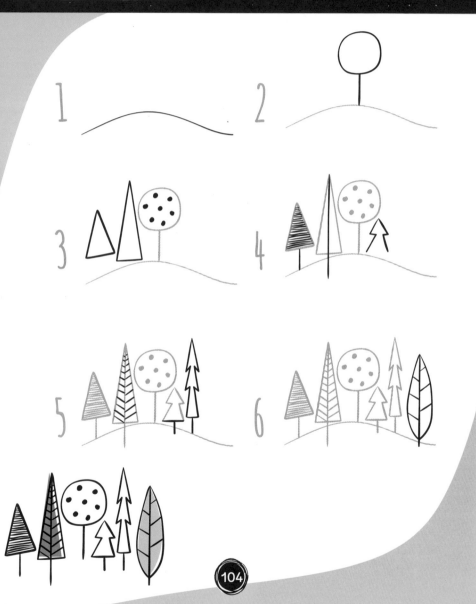

MOUNTAINS

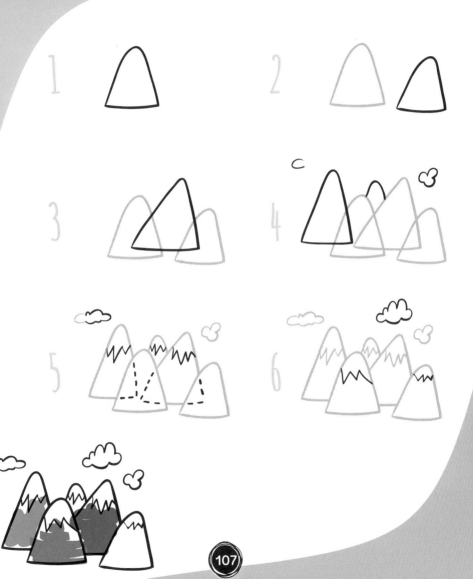

1

2

3

4

5

6

TRY *these* TOO!

Now that you're a pro at drawing the great outdoors, give this winter wonderland scene a try.

BAOBAB TREE

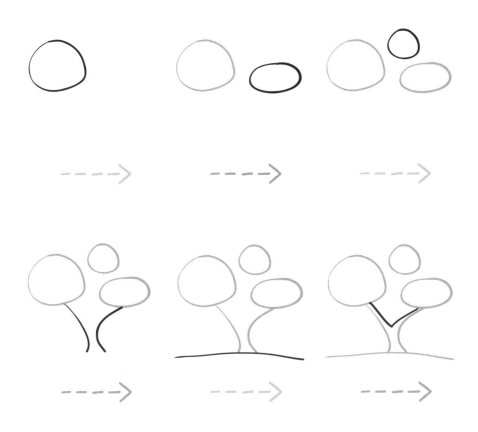

PEOPLE

In this chapter you'll learn how to draw people, from their faces to full bodies . . . all in just 6 easy steps! To get even more creative, try some of the suggestions for creating a scene with them on the opposite page and give the sketches a whirl on pages 124 and 125. And don't forget your 12-Step Challenge—see if you can draw the lady with the cake on page 126!

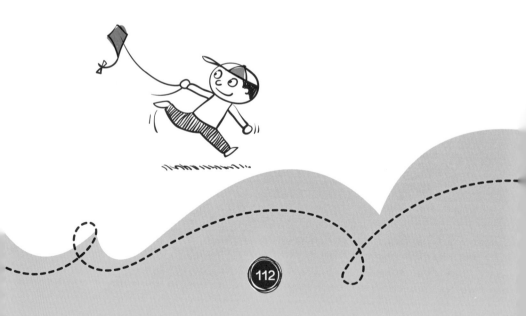

Here's Some
INSPIRATION

People are great for adding some life and action to your scenes.

Once you've mastered all the people in this chapter, try making a scene with them! This is the fun part. I put some suggestions below to jump-start your creativity. And don't hesitate to use your new sketching skills to modify any of the people here. Experiment with hairstyles and accessories, or have the people do different things. The sky is the limit!

- Draw the smiling boy with the sign (page 115) and write your name in fun lettering on the sign. Draw a bird (page 28) standing on its head! Then draw thought bubbles for the boy and the bird and write in what they are thinking!

- Draw the dancer (page 120) someplace unexpected . . . like running down the side of a volcano (page 108)! Write a story about how she got there.

- Draw the fisherman (page 117) at the edge of a body of water. Draw a couple of fish (page 40) under the water looking at him with a funny face. Draw thought bubbles and write what they are all thinking!

- Draw the cowboy (page 114). See if you can draw the rest of his body, with cowboy boots and a big oval belt buckle. Don't forget to give your character a name!

- Take one of the funny faces (pages 122 and 123) and try to draw the rest of the body. Draw one of the hats (page 125) on the person's head.

1

2

3

4

5

6

HOWDY!

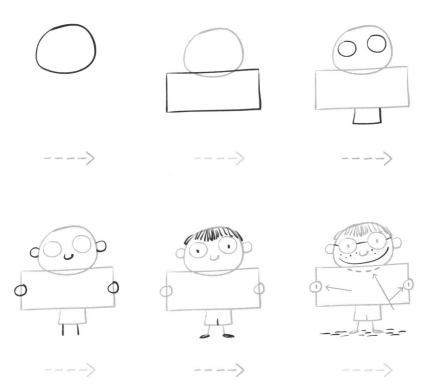

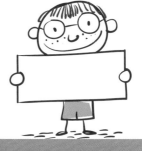

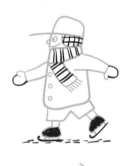

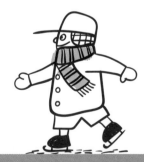

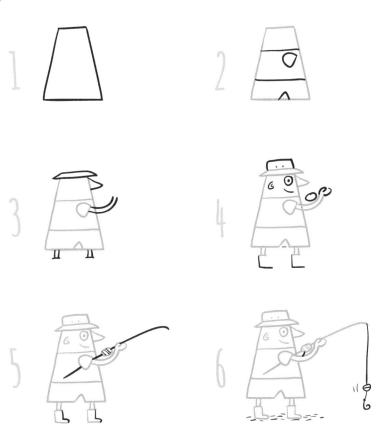

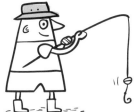

KITE FLYER

1

2

3

4

5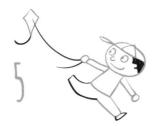

6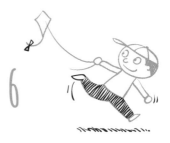

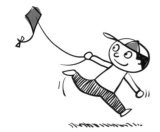

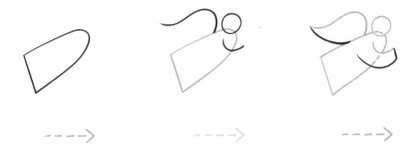

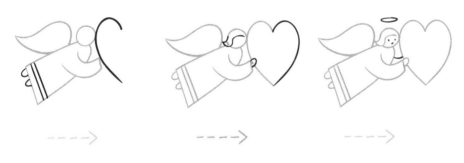

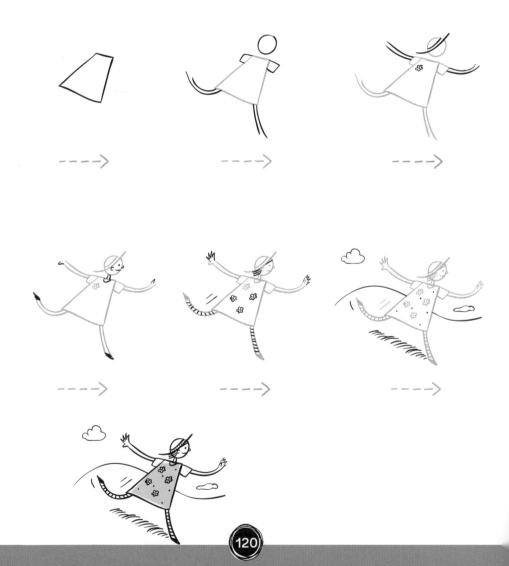

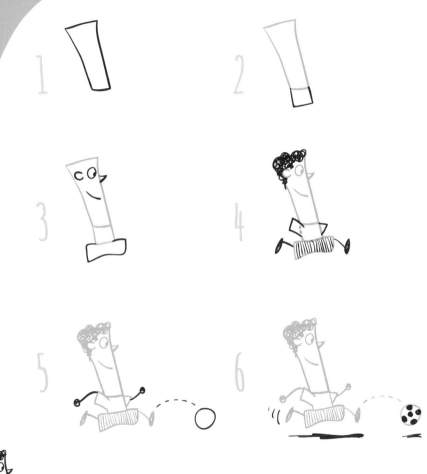

1

2

3

4

5

6

TRY *these* TOO!

Now that you're a pro at drawing people, give these characters and fun hats a try.

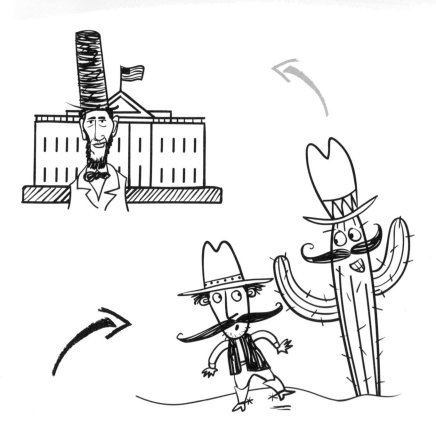

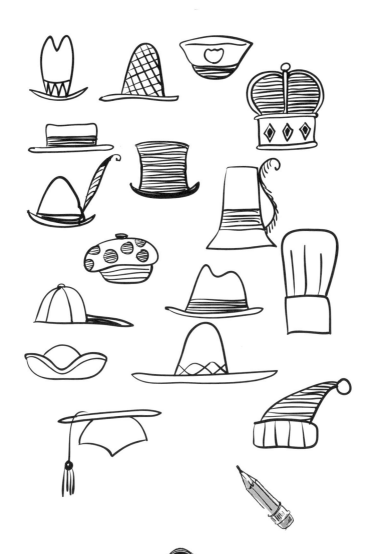

LADY WITH CAKE

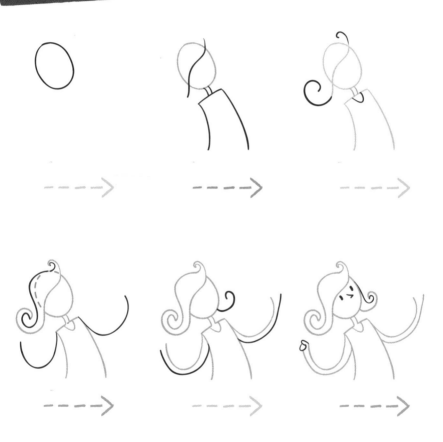

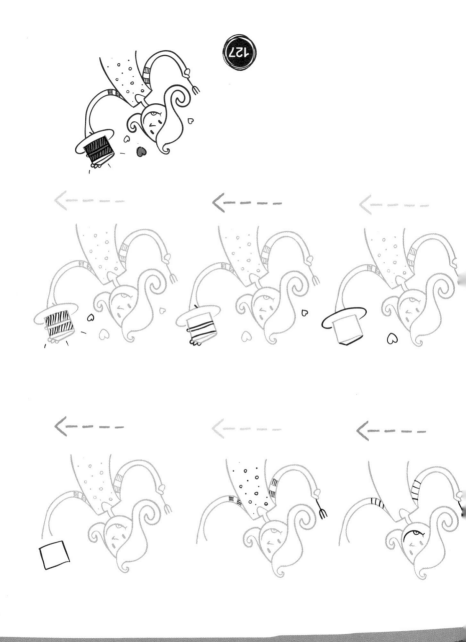

About the Author

Rich Davis is a professional artist, children's book artist, and drawing game inventor. He has published more than fifteen books, including the popular *Tiny the Dog* series. Rich teaches drawing instruction at schools and also created Pick and Draw, which he developed into both an activity book and game. He lives in Arkansas. On any given day, you might find Rich out on his front porch with his dog, Ringo, drawing with an ink pen in his sketchbook. After thirty years of producing art professionally, drawing simply has become his love.